ANSEL ADAMS

Color Photographs · A Postcard Folio Book

LITTLE, BROWN AND COMPANY

Boston New York Toronto London

D1580664

AUTHORIZED
EDITION

FIRST EDITION
ISBN 0-8212-2240-6
Published simultaneously in Canada by Little, Brown & Company (Canada) Limited
PRINTED IN THE UNITED STATES OF AMERICA

Front cover photograph: *Late Evening, Monument Valley, Utah, c. 1950*
Back cover photograph: *Ansel Adams* by Mimi Jacobs

FIRST-CLASS LETTER POSTAGE REQUIRED

Ansel Adams

enjoyed the unique distinction, among twentieth-century Americans, of being simultaneously the nation's best-known photographer and its best-known environmentalist. He brought a deep love for the natural beauty of California and the West to his work as an artist, and his twin passions reinforced one another to create photographs that have become veritable icons of our national parks and wilderness. He was an artist profoundly American in his vision, whose reverence for nature and generous optimism made him the visual spokesman for a new epoch.

Born in San Francisco in 1902, Adams grew up in a house on the sand dunes of the Golden Gate. His love affair with nature began in childhood, by the shores of the great Pacific. In 1916 he discovered Yosemite, and his destiny became increasingly clear. Although trained as a pianist, by the age of twenty-five he had decided on a career in photography. He was the country's most influential teacher of photography, giving literally hundreds of workshops and lectures, developing the famed Zone System of visualization and exposure control, and writing no less than ten highly influential photography manuals. While Adams is best known for his black-and-

white photographs, beginning in the 1940s he also made many outstanding color images from which the twenty-four images in this folio were selected.

Just as Muir's writings and leadership had made him the spiritual leader of the Sierra Club and philosopher-poet of the nascent environmental movement, Adams' photographs gave him a similar role as the movement came to fruition. His environmental activism was reflected in thousands of thoughtful, persuasive letters to public officials, meetings and telephone calls beyond number, and, of course, the magnificent photographs — the "Eloquent Light."

In 1980, Adams received the Presidential Medal of Freedom. The citation read by President Carter stated:

"At one with the power of the American landscape, and renowned for the patient skill and timeless beauty of this work, photographer Ansel Adams has been visionary in his efforts to preserve this country's wild and scenic areas, both on film and on Earth. Drawn to the beauty of nature's monuments, he is regarded by environmentalists as a monument himself, and by photographers as a national institution. It is through his foresight and fortitude that so much of America has been saved for future Americans."

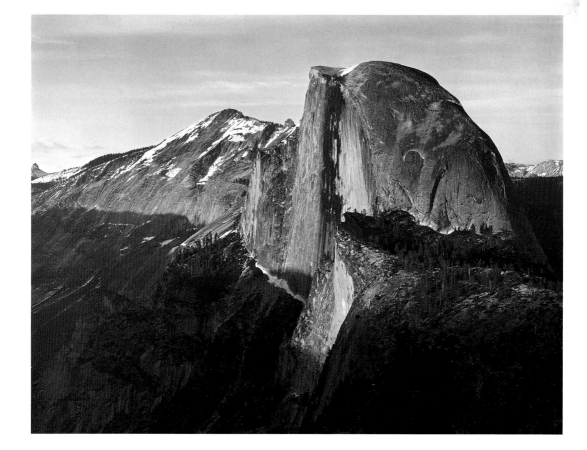

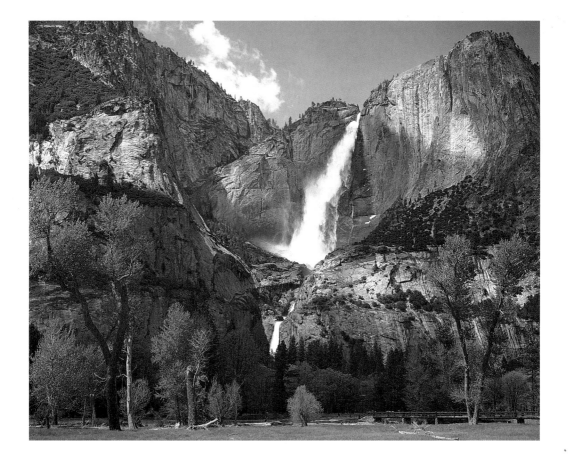

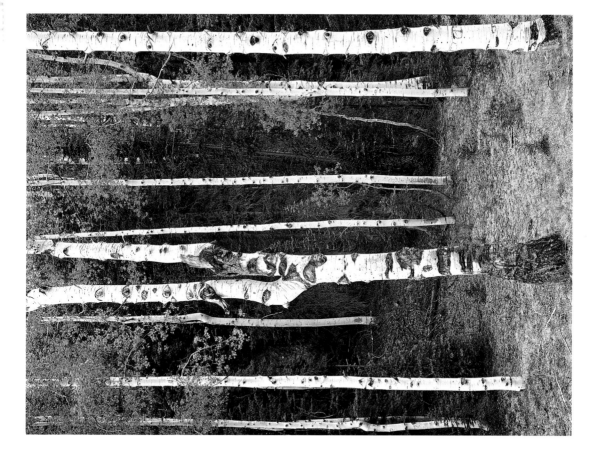

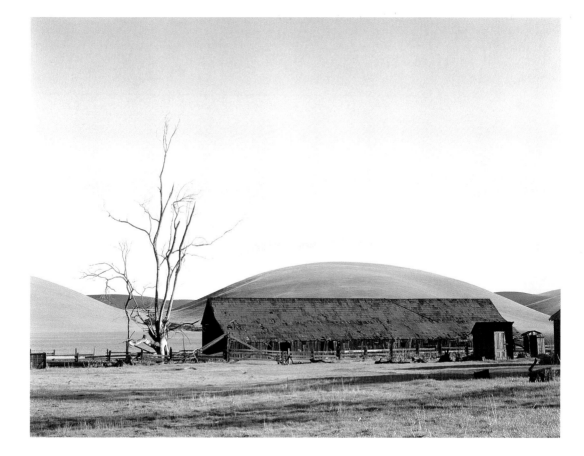

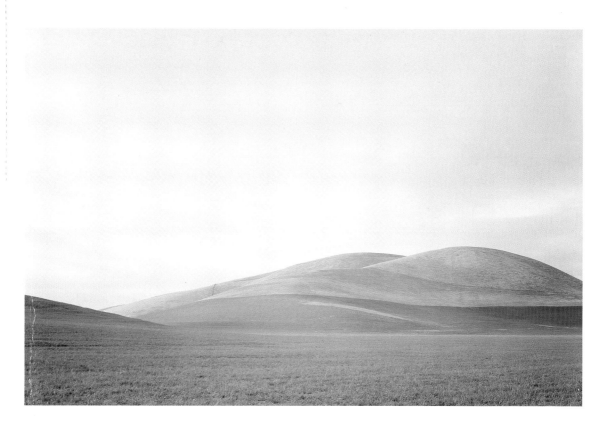

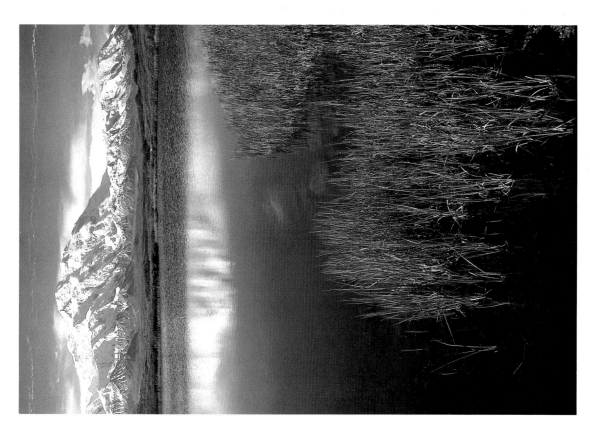

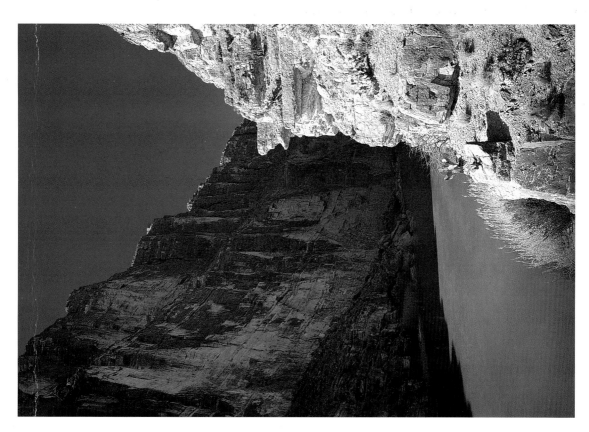

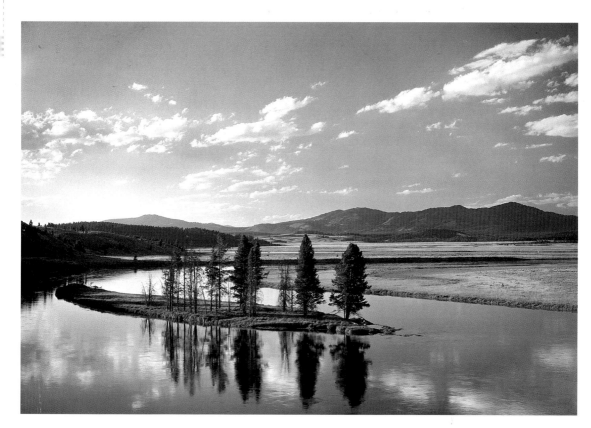

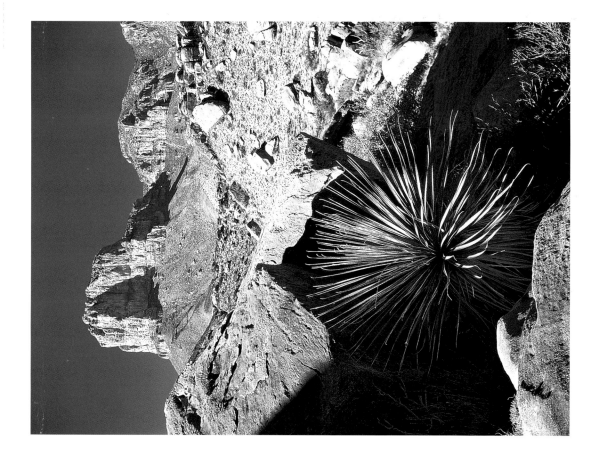

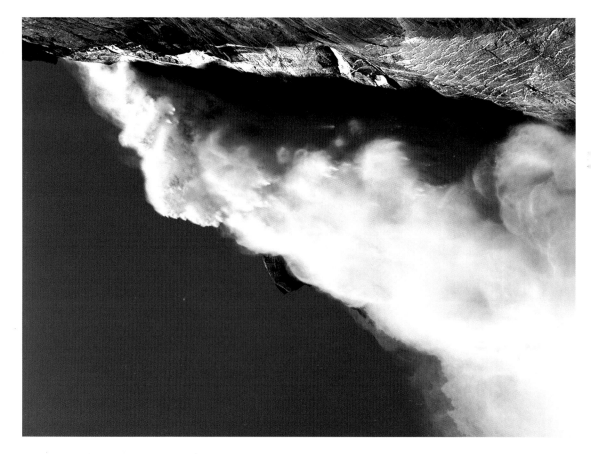

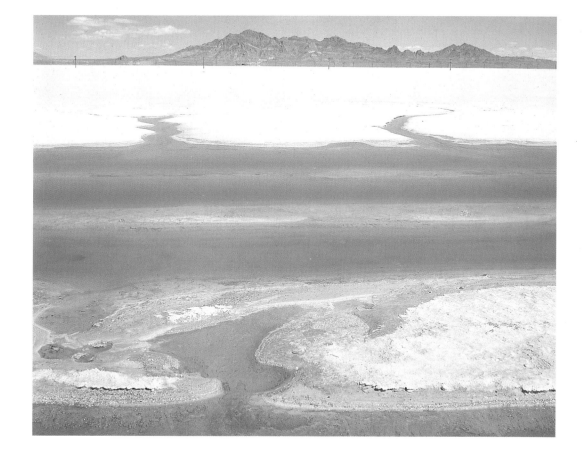

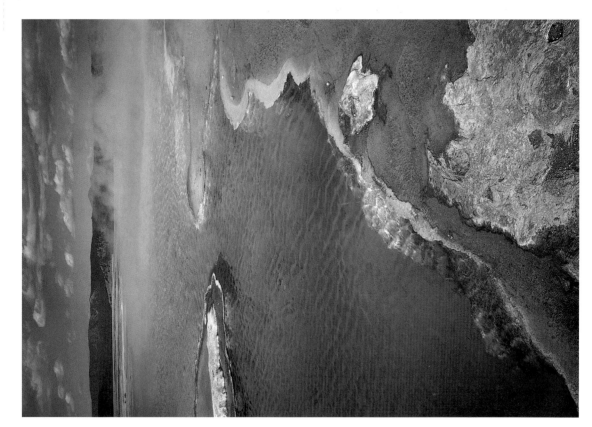

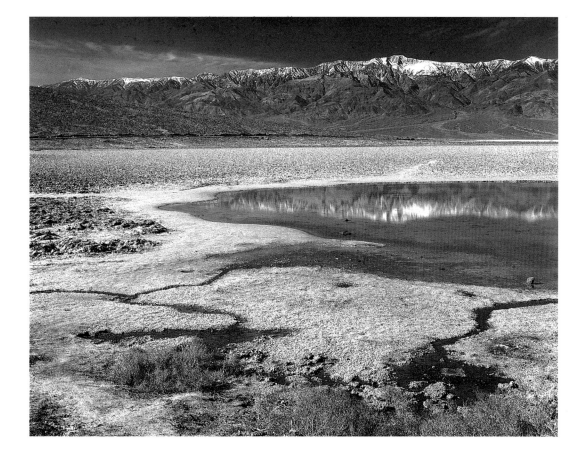

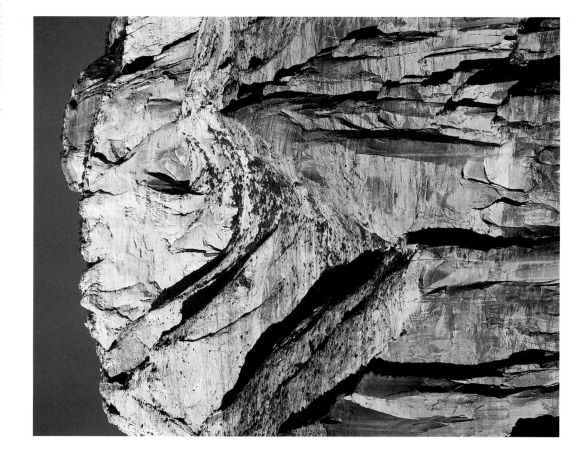

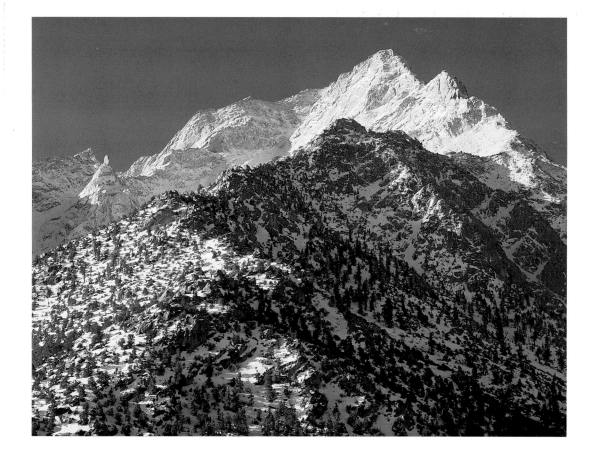

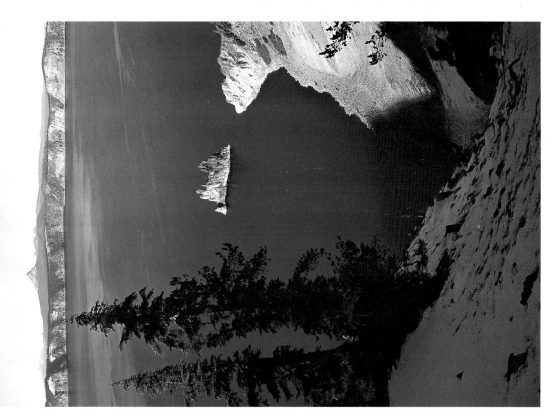

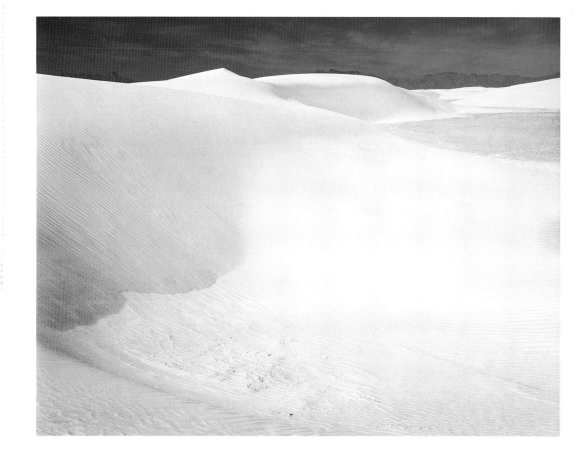

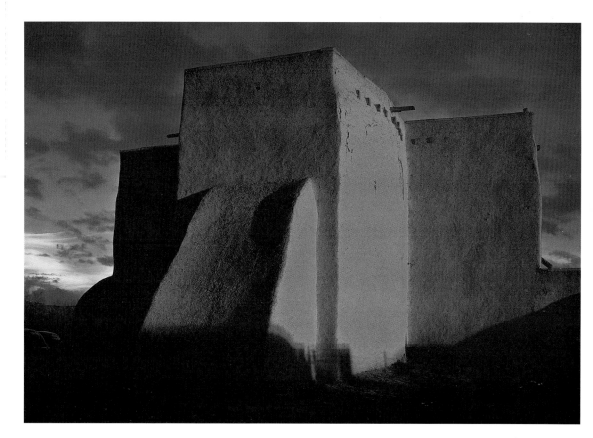

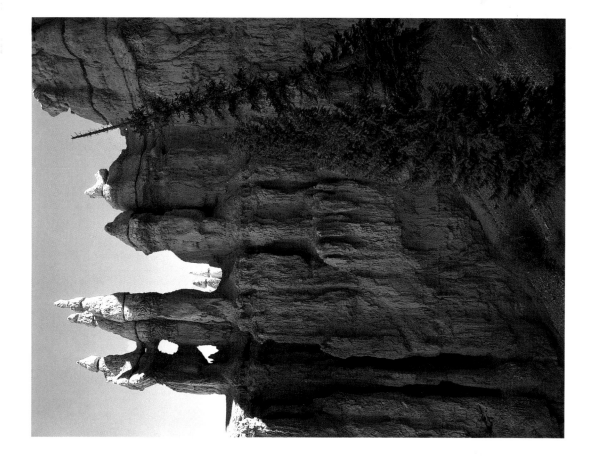

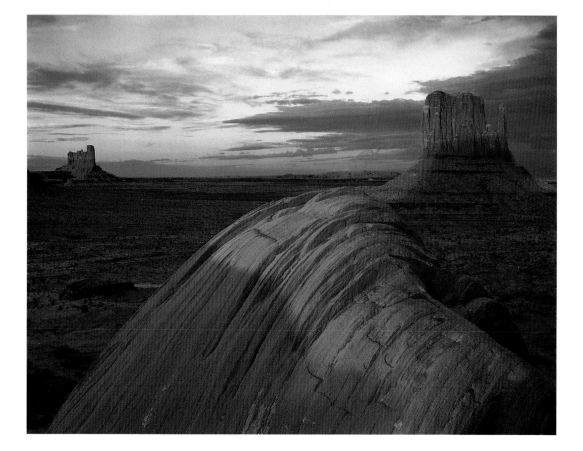

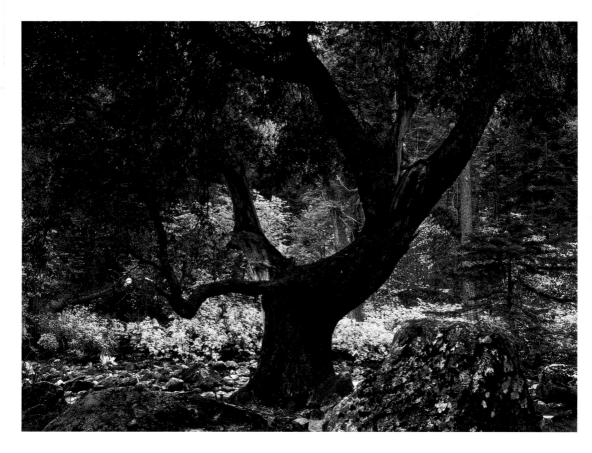

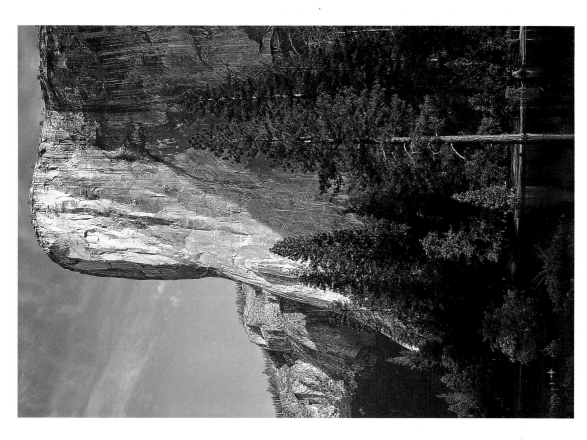

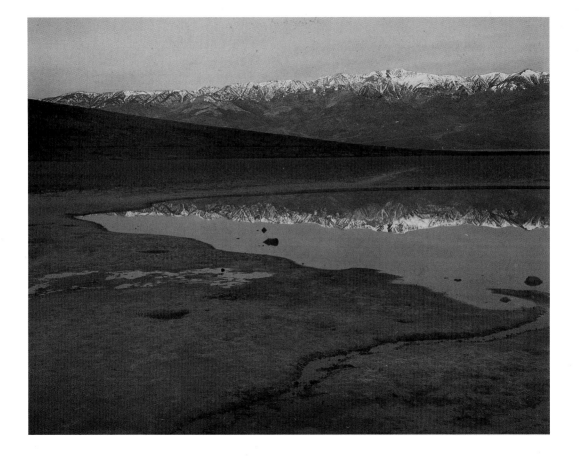

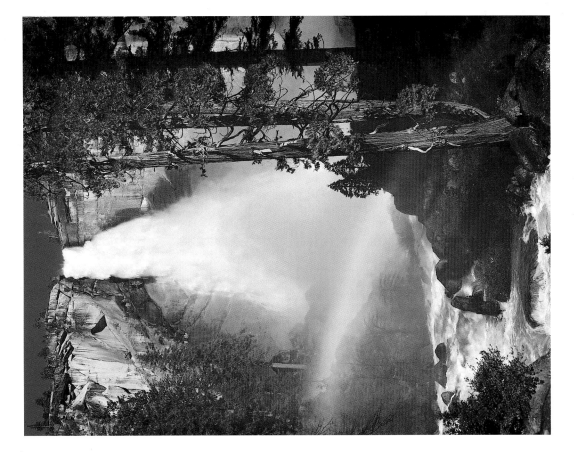